CØSPLAY FEVER RED

ABLAZE

Photography by
Rob Dunlop and
Peter Lumby

Introduction by
Rob Dunlop

Cosplay Creator Spotlight features
James, aka Ilpala
Natasha, aka MissyTetra
Tab
Anaïs, aka Zombiemama

Cover Models:

Front (left to right):

Back (left to right):

Marc plays Hayabusa
(from Halo 3)
Lilith plays Hungary
(from Hetalia)
Amanda plays Bayonetta
(from Bayonetta)

James plays Lord of Darkness
(from Legend)
Emma plays Wonder Woman
(from DC Comics)
Becca plays Princess Zelda
(from Legend of Zelda)

Cosplay Fever Red

Published in the UK
by Ablaze Media Ltd.
London, England

cosplayfever@gmail.com
www.cosplayfever.com

PRINTED IN SPAIN
ISBN: 978-0-9543008-4-5

COSPLAY FEVER RED

ROB DUNLOP ABLAZE PETER LUMBY

Introduction

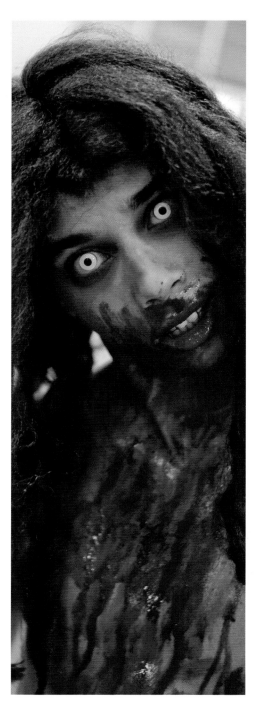

Pete and I have been attending anime and comic events around the UK since 2002, and in that time we've seen cosplay grow into the phenomenon it is today. For the uninitiated, the term "cosplay" refers to "costume role-play". Thousands of people across the globe regularly dress up and role-play as their favourite characters from comic books, anime, video games and other popular media. Why? Because it's fun, challenging, and a great way to meet new people and express one's creativity.

Many cosplayers create their own costumes, but some prefer to have them commissioned, or they source items from different places and assemble their outfits piece by piece. When pushed to its limits, cosplay requires tremendous skill, dedication and ingenuity, and the finished costumes can be genuine works of art.

You could say that Cosplay Fever Red is a photographic guide to a living, breathing exhibition. Our job, as photographers, is simply to let the costumes shine, and when we capture the true essence of one of these magnificent creations, it's great to know that another work of art has been documented for posterity. I sometimes feel like we're collecting rare butterflies - only we're not skewering the cosplayers with giant needles and putting them in a display case. Not this time anyway (mental note - great idea for a future project).

The first Cosplay Fever book was something of an experiment. We took thousands of photos at eight events over a five month period, then put the best shots in a book, sold it at conventions and waited for people's reactions. Thankfully, the response was very positive, and we're grateful for all the support we received, but we did get lots of constructive feedback, which has helped us enormously in the development of the sequel.

Cosplay Fever Red is a more refined, more complete product than the first book, and I like to think it's something that anyone who appreciates creativity would enjoy. We've tripled the number of events we've attended and spent a full year taking photos, so we've had a huge array of cosplays to choose from. As you can see from flipping through the book,

the quality of the costumes is extremely high, and choosing the final selection was no easy task. With so many photos to choose from, we've also been able to include a greater variety of costumes from a multitude of genres.

Perhaps the most requested feature for Cosplay Fever Red was the inclusion of series information alongside character names, and this has now been added. We've also included an index at the back of the book, organised by series, so you can find any costume in seconds. To make it easy to find the various DC and Marvel characters, we've grouped them together into their respective universes. So for example if you want to find Starfire from DC's Teen Titans comics, she's listed under "DC Universe", while Spider-Man is under "Marvel Universe".

We've also launched a brand new feature, called Cosplay Creator Spotlight. Among the people we've met over the last couple of years are four talented cosplayers: Ilpala, MissyTetra, Tab and Zombiemama. These guys are all, in their own unique way, pioneers within the UK cosplay scene, so we thought it would be interesting to discover a little bit more about who they are and what they do. We're very grateful to them for taking the time to share their thoughts.

It may have taken us a solid year to put this book together, but that's a drop in the ocean compared to the total time taken on the costumes inside it. There are even a few individual cosplays that took longer to make than this entire book. The cumulative blood, sweat and tears that has gone into the creations on display is mind-boggling, but I hope that as you turn the pages of Cosplay Fever Red, you'll agree that all that hard work has paid off. It has been a real honour to meet so many friendly, enthusiastic and talented people, and I look forward to skewering them all with a giant needle at some point in the future :)

See you at the next con!

Rob Dunlop

Cosplay Creator Spotlight

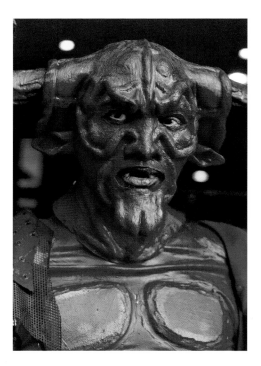

James
aka: Ilpala
website: www.cosplayisland.co.uk/overview/ilpala

Cosplay Fever: What first got you into cosplay?
Ilpala: When I started, the convention community was very small and the number of cosplayers even smaller. For me, the masquerade was still the highlight of the event though and after a few years of watching I really wanted to take part. I also love making things and I've found that cosplay is one of the best tests of ingenuity and creativity going, so it was probably a natural progression too :P

CF: What's your favourite cosplay that you created?
I: Oh, that's a tough one. Most of my costumes have a place in my heart and I still have almost all of them. Now that I've updated Vash the Stampede (from Trigun) and improved some of the elements I was originally disappointed with, I think it would have to be that one. Vash is easy to wear, has great props, big boots and as I'm sure any Vash cosplayer will tell you, it simply feels amazing to be dressed as Vash the Stampede!

CF: What's your most memorable cosplay moment?
I: Somehow I've managed to avoid anything too embarrassing happening whilst in costume, so my most memorable one would have to be when I wore the cosplay I just mentioned - Vash from Trigun. This was my first cosplay, and I think I was the first Vash in England. The reception was amazing, I still remember the exclamations of "Oh my god it's Vash the Stampede!" when I walked into rooms. My cosplay group won our first masquerade and I ended up stumbling back to our B&B through the centre of Southampton at 5am.

CF: What's your experience of cosplaying in public?
I: I've only occasionally cosplayed in public and normally in quite outrageous costumes, so in general the public just seem to enjoy the spectacle or ask for a quick photo.

CF: What's the hardest costume you've ever made?
I: Probably my Laputian Robot. The large curved surfaces, the need for the costume to break down for transportation and the articulation meant that a lot of thought had to be put into the superstructure.

CF: What's your favourite material to work with?
I: Foams such as Plastazote or funky foam, they're easy to work with and wonderfully versatile.

CF: Do you have any advice for a first time cosplayer?
I: Have fun and be awesome to one another, nothing else matters as much as this. Cosplay is many things to many people, so concentrate on what you enjoy, be it construction, performing or just wandering around and making friends.

CF: What anime, manga or video game are you enjoying right now?
I: I just finished watching Macross Frontier and I'm hoping to be able to find some time to play Final Fantasy XIII and Transformers: War for Cybertron soon. Most of my spare time is taken up organising cosplay events like Amecon or EuroCosplay though.

CF: What are your cosplay plans for the future?
I: Moooooooore robots, if I can find any more space in the house that is! I've also been planning to make a Ryuk costume from Death Note for some time. One day it might happen.

Natasha

aka: MissyTetra
website: www.missytetra.co.uk

Cosplay Fever: What first got you into cosplay?
MissyTetra: The simple answer is Pokémon. The real answer is that I just grew into it, the way you grow into an awesome pair of shoes that your parents bought which were three sizes too big for you. I always loved geeky things (most of them Japanese), liked to make stuff, and adored dressing up. Cosplay enables me to combine all of my hobbies and passions, and it's the only hobby I have that allows me to keep dreaming the way I did when I was a child!

CF: What's your favourite cosplay that you created?
MT: The most fun to wear is definitely Princess Peach, because it's an excuse to be a complete airhead, block emergency exits with dress-poof, randomly pluck mushrooms and vegetables from beneath your skirt, and know that you're secretly a genius who splits kidnap ransoms with a giant tortoise king. Plus I love to swan around in big gowns, and Princess Peach is one of my most comfortable and most worn costumes!

CF: What's your experience of cosplaying in public?
MT: The most common response is "WHAT'RE YOU WEARING?!". Generally I've only really gotten two reactions - shouts that are supposed to be insults (some of them are quite flattering really, such as if I'm dressed as Princess Zelda and someone yells "Do you think you're a f**king princess or summat?!"), or I get the inquisitive children, and their parents, asking me why I'm dressed a bit funny. Mainly, people just want to prod, poke, ask, or provoke a response, to check that they're not hallucinating and that I'm actually human, as opposed to being vaguely elf, persocom, or an alien that's about to unleash its tentacles on the world!

CF: What kind of characters do you identify with most?
MT: I tend to cosplay strong women. Or really dumb ones. I don't really identify with them, but it's fun to play them! The characters I do identify with are those who can't seem to communicate their true emotions to others. Having said that, I think it's hard to find just one character who has been

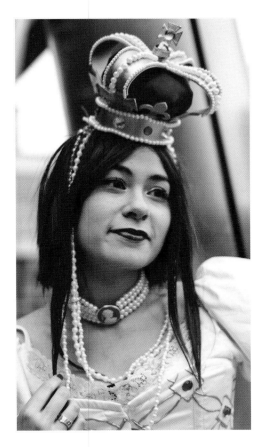

designed to have the same soul as I have, so I just take each one of my personality quirks to its ultimate extreme!

CF: Do you have any advice for a first time cosplayer?
MT: Choose a costume that you can make, to avoid disappointment - you can get bigger and better as time goes on! Ignore people that try to put you down. You will get them, but there are so many more people willing to help you than there are people who would shun you. Have faith in the geek community!

CF: What are your cosplay plans for the future?
MT: Well, I wouldn't want to ruin the surprise! But a few from my list are: Samus Aran (Metroid), LadyDevimon (Digimon), Queen of Hearts (original design) and Zephie (MagnaCarta 2) <3

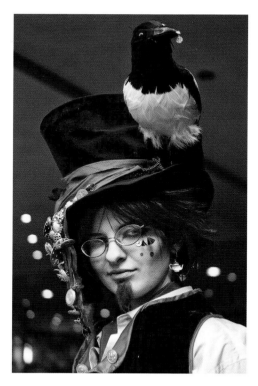

Tab

website: www.khaoskostumes.com

Cosplay Fever: What first got you into cosplay?
Tab: A local book store ran an anime event, which had some cosplayers attending. It looked like a lot of fun, so I figured I'd have a go.

CF: What's your favourite cosplay that you created?
T: I have two. As far as how it looks and how pleased I was with it, I would have to say my Siegfried costume. My favourite to wear is my own original creation, Billy Strings, because it's a very comfortable costume and he's a great character. He's Texan and I get to do a lot of funny stuff with him. The reaction to him as a character from other people can be quite amazing. I once did a crossplay panel as him in character, voicing his generic Texan accent throughout the whole thing.

CF: What sets you apart from other cosplayers?
T: I do commissions now, which I'm doing more as a business, and so the most important thing is to use high quality materials. I stick to the motto "always use the most expensive fabric you can afford". It doesn't mean you have to spend tons of money on something that's not worth it, just go with the best materials you can buy. There's a reason some materials are more expensive!

CF: Do you have a favourite material that you work with?
T: When making armour, my favourite material is Plastazote. It's a type of foam which I used to make the Big Sister helmet. It's comfy, light and very squishy, so it won't hurt you if people run into it.

CF: What kind of characters do you identify with most?
T: In general, I like steam punk. With original characters you can go as nuts with them as you want. For me, it's never about easy costumes, it's about showing off your skills. So with steam punk you can make it as easy or as difficult as you want to, but you can also make something very comfortable.

CF: Do you try to tackle a different challenge in every costume?
T: Yeah, I'm looking to do a material based, highly embroidered costume next. I haven't really had a chance to do that, because people like to see the big and impressive armour-based costumes. When it boils down to it, I'm actually better at sewing than I am at making armour.

CF: How long on average do you spend on a costume?
T: I work making costumes full time now, so it can vary. I spent about a month on Siegfried, but most commissions I make in about two or three days, so I can work quite quickly really.

CF: What anime, manga or video game are you enjoying right now?
T: I'm watching the new Full Metal Alchemist, which is pretty good. Despite making video game costumes, I'm not much of a gamer. My partner plays video games though, so I just tend to watch. I have terrible hand-eye co-ordination.

CF: What are your cosplay plans for the future?
T: I have some Arkham Asylum costumes that are half-finished, but for now I'm focusing more on my commissions.

Anaïs

aka: Zombiemama

website: www.undeadcosplay.deviantart.com

Cosplay Fever: What first got you into cosplay?
Zombiemama: I always loved costuming and cosplay was a natural progression of being creative and dressing up.

CF: What's your favourite cosplay that you created?
Z: Probably the zombie Disney group, because it's the most original and challenging, but also fun to wear. I must have made around 15 costumes in all, taking about two months. A lot of the work is in the make-up, especially for zombies.

CF: What's your most memorable cosplay moment?
Z: Probably when we dressed as the Disney zombies. From the back we looked perfectly normal, but from the front we looked absolutely horrific. At Midlands Expo, two little girls came running up behind us, shouting "Disney Princesses! Disney Princesses!". When we turned around, they ran away screaming!

CF: What kind of reactions have you had from cosplaying in public?
Z: Every time we go to a con in London, we pretty much travel in cosplay from my front door to the convention and back again. We get a lot of looks. The lovely woman who works at my train station gets much delight seeing us every single time in something new. Other people recognise the characters, and sometimes children come up and give me hugs.

CF: What costumes are you most drawn to?
Z: I love badass girls with guns, like Lara Croft, or Revy from Black Lagoon. I mainly prefer costumes from video games or comic books. I'm a big fan of comic book characters, and I have a list of at least 30 that I need to cosplay. I like original characters too. The chance to make and design my own stuff is really important.

CF: How long on average do you spend on a costume?
Z: I can spend anything from 24 hours to two weeks solid on a costume. If it's just for me, it's pretty quick, but if I'm working on a group, I have to make sure all the costumes are cohesive and everything looks just right. In the last 18 months, I think I've made around 30 costumes that weren't worn by me. I guess most people make or buy one costume for themselves within a group, but I'm a power-hungry control freak, so I try to make as much as I can within the group - as long as nobody minds!

CF: What's your favourite material to work with?
Z: Latex! Making my Silent Hill nurse costume was the most fun, and it was the cheapest costume ever. Only £8, and that was for the shoes. The mask was made of things found in my home, but I can't say what, it's a secret!

CF: Do you have any advice for a first time cosplayer?
Z: Do your research and know your type. Look outside the box for cheap solutions.

CF: What are your cosplay plans for the future?
Z: There's a movie coming out shortly called Sucker Punch. I'm trying to get a group of five girls together for that, because of the sexy costumes. Lots of leather and fishnet, swords and guns! We're also planning a steampunk group. Oh and I'd like to do Bayonetta.

strike a pose

"you know nothing about me, Doctor!"

Bexi plays:
Supreme Dalek Princess
from Doctor Who

Costume:
part self-made, part bought
"the bumps on the dress took
the longest. All the decoration
was handmade, so took forever"

The best thing about this
costume is:
"the weapons - they make me
feel powerful"

I love this character because:
"she is my original creation,
and she is awesome, funky
and evil!"

"cosplay is a dish best
served with a smile :)"

Stephanie plays:
Amulet Spade

Karen plays:
Amulet Diamond

Victoria plays:
Amulet Clover

Zoë plays:
Amulet Heart

All from Shugo Chara!
All costumes self-made

12

Katherine plays:
Utena Tenjou
from Revolutionary Girl Utena

Costume:
commissioned
"cost £220. I commissioned it
from Drunken Princess. It's fun
trying to get through doorways!"

I love this character because:
"the series is so mature and full of
symbolism - it is as beautiful and
noble as the character herself"

Sean plays
Batmar
from The Dark Knight

Costume:
by Universal Designs
"it was very expensive, but well worth it!"

The best thing about this costume is:
"the leather and kevlar suit - so cool!"

I love this character because:
"he's very moody and dark"

"live your dreams"

14

"HA HA HA!"

"worship me!
I have cake!"

Clare plays:
Harley Quinn
from Batman:
Arkham Asylum

Costume:
self-made

Joshua plays:
The Joker
from Batman:
Arkham Asylum

Costume:
self-made

15

Emma plays:
Jeanne
from Bayonetta

Costume:
self-made
"took 1 month. Made from scratch"

The best thing about this costume is:
"I feel fantastic"

I love this character because:
"she's feisty"

"be creative"

Amanda plays:
Bayonetta
from Bayonetta

Costume:
self-made
"took 1 month solid. The hair
was a huge challenge too!"

The best thing about this
costume is:
"the epic hair!"

"do you naughty little angels
deserve a good spanking?"

"hug me and feel my wrath - just kidding, just don't touch me"

Joe plays:
the last Kusagari
from Red Steel 2

Costume:
self-made
"cost less than £50"

I love this character because:
"he comes to town to kick butt
and chew bubblegum, and he's
all outta gum"

"dance like nobody is watching!"

Laura plays:
Amaterasu
from Okami

Costume:
self-made
"took 3 weeks"

I love this character because:
"she uses art to fight evil!"

19

Amie plays:
Jenova
from Final Fantasy VII

Costume:
self-made
"took 7 months"

The best thing about this costume is:
"the helmet - although it's heavy"

I love this character because:
"Jenova is a big part of the story"

Hannah plays:
Hitsugaya
from Bleach

Costume:
self-made
"took 5 months,
cost £150+"

Stephanie plays:
Kero
(original creation)

Costume:
by Magpie Bones
"the costume was commissioned, but the
Lolita outfit was bought separately"

The best thing about this costume is:
"the cute outfit and the reaction from
the public"

I love this character because:
"it's fluffy"

Rachel plays:
Fever
(original creation)

Costume:
self-made

"cosplay is for fun - not serious!"

Azara plays:
Alice
from Pandora Hearts

Costume:
bought
"the dress cost £70, the wig was
£40. Both came from Malaysia"

I love this character because:
"she's completely misunderstood and
crazy, and also very mysterious"

"be graceful to everyone you meet!"

Yaya plays:
Mulan
from Mulan

Costume:
self-made
"took 3 days"

I love this character because:
"she is a great legend in China,
my home country"

"HAHAHAHAHA!"

I-Ching plays:
Haruko Haruhara
from FLCL

Costume:
part self-made, part bought
"took 4 days to make the
jacket. The rest was bought"

The best thing about this
costume is:
"she is mad, hahaha!"

I love this character because:
"she is left-handed and has
a left-handed bass guitar -
just like me!"

James plays:
Canti
from FLCL

Costume:
self-made
"took 1 month, cost £100. Making
the TV screen was challenging"

I love this character because:
"his design is unique"

"try to believe
6 impossible things
before breakfast"

Ebbiny plays:
Fifth Doctor
from Doctor Who

Costume:
self-made
"took 3 weeks"

The best thing about this
costume is:
"looking like an Edwardian
cricket player"

"to my girls at ontd_startrek - stay fierce GQMFs!"

Alice plays:
Gaila
from Star Trek

Costume:
self-made, phaser + wig bought
"the green paint took forever to apply and it's difficult to get it looking even. Other than that, it wasn't too difficult or expensive to put together"

I love this character because:
"she's really interesting visually. She's also the only Orion to enlist in Starfleet"

"I love the Queen!!"

Ramona plays:
Queen of Hearts
from Alice in Wonderland
(dark version)

Costume:
self-made
"took 2 weeks, cost 300 euros.
This costume has not been
entered into any contests -
I made it especially for this
event (Grand Cosplay Ball)"

"have enough patience and you'll find out you can make anything!"

Kelsey plays:
Mad Hatter
from Alice in Wonderland

Costume:
self-made
"took 2 months, cost £300.
The challenging part was
building the top hat
from scratch"

I love this character because:
"he has such a strange
personality and great
make-up, with a
fantastic hat!"

"the power of love conquers all!"

Grace plays:
Star Sapphire
from DC Comics

Costume:
self-made, plus friend
"it was modified from a full
bodysuit. The most challenging
part was getting everything to
stay together"

I love this character because:
"she's a strong sexy woman!"

"with great power comes
great responsibility"

Nicholas plays:
Spider-Man
from Spider-Man

Costume:
self-made
"took a year to make. I had to learn
how to sew and paint the webs on,
which took a lot of patience"

I love this character because:
"he is the hero I grew up with"

"everyone get a
sewing machine!"

Kaman plays:
Leviathan
from Megaman Zero

Costume:
self-made
"cost £20! Woooo!"

The best thing about this
costume is:
"it's lycra!!!"

I love this character because:
"it has an awesome helmet!"

"POWER UP!"

ECM

Ryan plays:
Kamen Rider Decade
from Kamen Rider Decade

Costume:
by Aniki

The best thing about this
costume is:
"it's badass!"

I love this character because:
"he's the destroyer of worlds"

Marta plays:
Chun-Li
from the Street Fighter games

Costume:
by Silvia
"I didn't make this costume -
it was made by my fellow cosplayer
Sylvia (we exchanged costumes for
the day). But I know there was a
lot of hard work involved!"

The best thing about this
costume is:
"the details"

I love this character because:
"she is a powerful woman
and very skilled"

"if you've got it, flaunt it, but for God's sake make sure it fits!!!"

Sonia plays:
Juri
from Super Street Fighter IV

Costume:
self-made
"took 3 days, cost £100. The challenge was making it fit without any wardrobe malfunctions! And the hair, OMG the hair - half of it is real, half fake"

The best thing about this costume is:
"it's cool to wear in a hot room, and it's all fabric, no tit-tape, hehe"

I love this character because:
"she's so cute!"

37

"KABOOOOM!!!"

Luke plays:
the Demoman
from Team Fortress 2

Costume:
self-made
"took 2 weeks, cost £130.
Army surplus stores are brilliant"

The best thing about this costume is:
"the tactical vest is useful for storing
everything I need at a convention"

I love this character because:
"he's a mad black Scottish
one-eyed explosives nutcase
with drink and anger issues"

"if you are going to cosplay a masked character, drink plenty of water!"

Matt plays:
HUNK
from Resident Evil 4

Costume:
self-made
"the mask is very warm!
A lot of the gear is difficult
to modify, as the material
is very tough"

The best thing about this
costume is:
"it's so fun to wear"

I love this character because:
"he's a significant but
mysterious figure in the
Resident Evil universe"

"try new things - nobody will know if you mess up"

Kirsty plays:
Little Sister
from Bioshock

Costume:
self-made, ADAM Needle and eyes
by Khaos Kostumes
"took 3 days to make the plain dress -
it was so cute before it was dirty"

The best thing about this costume is:
"the eyes - they really add to the creepiness"

I love this character because:
"the Little Sisters are adorable
but terrifying"

Tab plays:
Big Sister
from Bioshock 2

Costume:
self-made
"I made most of the costume 2 weeks
before the con, so it was very hectic"

I love this character because:
"she's creepy!"

"if at first you don't succeed,
use safety pins"

Louise plays:
Prince Crescendo
from Eternal Sonata

Costume:
self-made
"took a few weeks. I used nearly
40 metres of gold bias tape!"

The best thing about this
costume is:
"THE CAPE!!"

I love this character because:
"his wife is hawt! :)"

42

"don't mess with a claymore!"

Bethan plays:
Teresa
from Claymore

Costume:
self-made
"took a few months, but was quite cheap.
The most expensive thing was the wig,
which cost £10. The hardest part
about this cosplay is squeezing into
my catsuit!"

The best thing about this costume is:
"the epic sword!"

I love this character because:
"she's feisty and stands up for
what she believes in"

Blue plays:
Schrödinger
from Hellsing

Costume:
by a friend

I love this character because:
"he is crazy!"

"cosplay what you feel comfortable in and you'll have fun"

Asten plays:
Seras Victoria
from Hellsing

Costume:
self-made
"cost 100 euros. The hardest part
was the waist fitting"

The best thing about this costume is:
"fake breasts"

I love this character because:
"she's cute and badass
at the same time"

"keep on cosplaying!"

Sean plays:
Abel Nightroad
from Trinity Blood

Costume:
self-made, plus eBay
"the wig took a few weeks of continual
hairspray, the rest was very fast!"

The best thing about this costume is:
"the wig and the scythe made by Clone"

I love this character because:
"he is sweet and innocent one minute,
then scary and badass the next!"

"yes, it is possible to remove the innards of a military aircraft then wear them on your head!"

Natasha plays:
Seth Nightlord
from Trinity Blood

Costume:
self-made
"took 3 days, was rather cheap. The hardest thing is keeping cool!"

The best thing about this costume is:
"the possibility of taking off at any moment!"

I love this character because:
"what's not to love about a girl who wears a hat 3 times the size of her head and 3 times her body weight?"

47

"STAY METAL!!"

Tom plays:
Solid Snake
from Metal Gear Solid

Costume:
bought
"took 3 weeks to assemble.
The webbing / tact vest was
the hardest to find"

The best thing about this
costume is:
"I look badass"

"bottle tops are good for cosplay!"

Victoria plays:
Jill Valentine
from Resident Evil 5

Costume:
self-made
"took 4 months. The hardest bit was sizing - I had to remake the back, because I'd made it too tight! There was also a lot of sewing, whilst wearing the costume"

The best thing about this costume is:
"the boots and the bottle caps on the back. Plus it's got guns!"

I love this character because:
"she kicks ass! Even though she's being a bad character, she's really a good one :)"

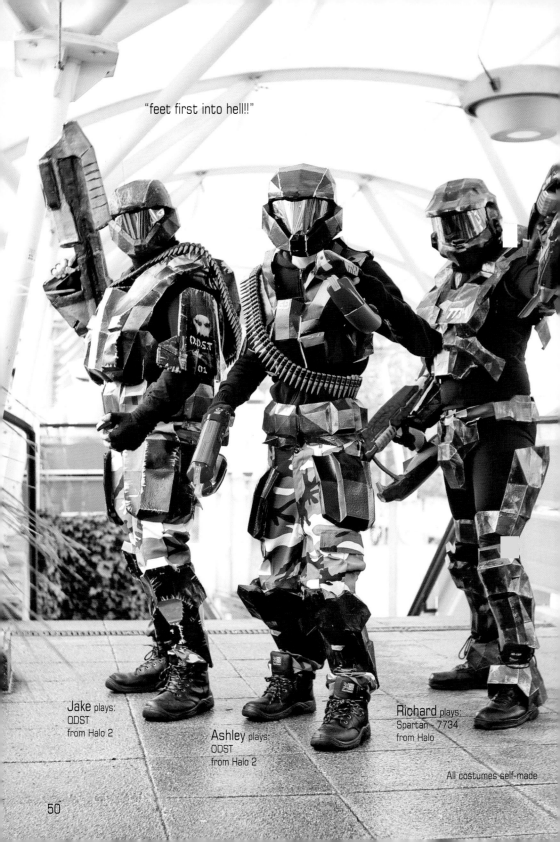

"feet first into hell!!"

Jake plays:
ODST
from Halo 2

Ashley plays:
ODST
from Halo 2

Richard plays:
Spartan - 7734
from Halo

All costumes self-made

"Spartans never die, they are just lost in action"

Marc plays:
Hayabusa
from Halo 3

Costume:
self-made
"took 7 months, cost £2500.
The hardest part was the
sniper rifle"

"no, a big sword and gun does NOT automatically mean I'm overcompensating for something!"

Rue plays:
Nero
from Devil May Cry 4

Costume:
part self-made, part commissioned
"cost £200+. The sword took 2 weeks and was almost a disaster - I used the wrong glue and melted a hole in the side, which I fixed, after a panic! The hems on my coat kept fraying too"

The best thing about this costume is:
"the coat - it swishes when I walk! XD The sword makes me happy too!"

I love this character because:
"I like the weapons and his sheer attitude!"

"more people should cosplay! ^_^"

Katie plays:
Kain Highwind
from Final Fantasy IV

Costume:
self-made
"took 100 hours,
cost £60. The whole thing
is made of craft foam,
PVA and acrylics"

The best thing about this costume is:
"it turns a lot of heads, and makes me
look taller than I am ;P"

I love this character because:
"he's noble, proud and dignified -
the opposite of me"

Jenny plays:
Kuja
from Final Fantasy IX

Costume:
self-made, plus friend
"took 1 month, cost £100. The jacket
sleeves were the hardest part"

The best thing about this costume is:
"the jacket"

I love this character because:
"he looks like he's in drag"

"always challenge yourself!"

Liz plays:
Ectvarr
from N3: Ninety-Nine Nights

Costume:
self-made
"took 1 month, cost £450.
Challenges included dying the
fabric, fitting the jacket, and
the beads!"

The best thing about this
costume is:
"I'm the third person to
ever cosplay it"

Kara plays:
Terra Branford
(Amano version)
from Final Fantasy VI

Costume:
part self-made, part bought
"took 1 year to make, cost
£200+. The challenge was
threading every single bead"

"enjoy the moment!"

Elandria plays:
Lanny
from Aion MMORPG

Costume:
self-made
"took 2 weeks. I used more
than 50 metres of ribbon
for the details"

The best thing about this
costume is:
"the boots!"

I love this character because:
"it's original, based on
Spiritmaster designs"

"pum, pum, pum pumpkin!"

Lisa-Marie plays:
Blair
from Soul Eater

Costume:
self-made
"this was a rush job, cost £40
including the wig and contacts.
The hat and boots were awkward
to construct and wear XD"

The best thing about this
costume is:
"the sleeves, cos I can flail
like a moron!"

I love this character because:
"she's fun and bubbly and is a
good excuse to run around in
Hyper mode"

58

"don't sweat the petty things and don't pet the sweaty things!"

Katie plays:
Excalibur
from Soul Eater

Costume:
self-made
"cost £50. It was my first attempt at mask making, which was really tricky"

The best thing about this costume is:
"the mask!"

I love this character because:
"he's so annoying!"

"peace & love"

Ken plays:
Joachim
from Castlevania:
Lament of Innocence

Costume:
commissioned
"the boots are second-hand
riding boots and cost £6,
the main costume was
commissioned and cost £66,
the wig was £20 from eBay"

The best thing about this
costume is:
"it's stylish, Gothic, historical
and romantic"

"Sheryl nom nom nom...
watch Macross Frontier please"

Jia plays:
Sheryl Nome
from Macross Frontier

Costume:
part self-made, part tailored
"took 5 days, cost RM300+
(Malaysian ringgit)"

The best thing about this costume is:
"SM vinyl shorts, ha ha. The entire
'stage presentation police outfit'
concept is awesome"

"cosplay is so addictive it
should be a drug!"

Kelly plays:
Kallen
from Code Geass

Costume:
commissioned
"cost £50. It was commissioned
from eBay, but I had to make a few
alterations myself, as it was
a little too big!"

I love this character because:
"she's fully capable of
taking care of herself!"

Laura plays
C.C.
from Code Geass

Costume:
was a gift
"it was a Christmas present
from 2 or 3 years ago

The best thing about this
costume is
"the wig - despite how
matted it now is
I just can't help but
love green hair"

Carla plays:
Sakura Kinomoto
from Cardcaptor Sakura

Costume:
self-made, plus Steph
"took 2 weeks+ for the outfit and
another 2 weeks to edit the boots"

The best thing about this costume is:
"the shoulder pads, because I love how I
can attach a plushie on there"

I love this character because:
"it is the first ever anime
that I fell in love with!!"

"hey world,
where are you?"

Charlotte plays:
*Xerxes Break
from Pandora Hearts*

Costume:
self-made
"cost £70+. It's all hand-sewn,
and in 5 bits"

The best thing about this costume is:
"Emily, the little plushie on my shoulder
too cute and creepy"

I love this character because:
"he's a creepy crazy character
and contrasts with the Mad Hatter –
what could be better?"

"the Queen of Hearts made some tarts, all on a summer's day"

Emily plays:
Oz Vessalius
from Pandora
Hearts

Costume:
self-made

Samuel plays:
Gilbert Nightray
from Pandora
Hearts

Costume:
by Charlie

"watashi wa aku made
shitsuji desu kara"

Rue plays:
Sebastian
from Black Butler

Costume:
part self-made, part commissioned
"took 3 weeks. It involved styling
the wig, sourcing the props and
sewing on the MANY buttons!"

The best thing about this
costume is:
"the contacts and the tailcoat -
I LOVE the tailcoat! XD"

I love this character because:
"he's a demon butler! Enough said!"

"cosplay rocks socks"

Rebecca plays:
Ciel Phantomhive
from Black Butler

Costume:
self-made
"took 1 month. The biggest
challenge was the hat"

The best thing about this
costume is:
"the bustle - it makes
my bum big and I like it"

I love this character because:
"he's so moody"

67

"take one step at a time, to get what you want"

Nikki plays:
Esther Blanchett
from Trinity Blood

Costume:
self-made
"took 6 months,
cost £150"

Elsa plays:
Astharoshe Asran
from Trinity Blood

Costume:
self-made
"took 5 months, on and off. The entire
costume was a major challenge and
thoroughly tested my love of cosplay! But
now it is finished (or close enough!) every
moment was worth it"

The best thing about this costume is:
"I get to be an aristocratic vampire
for the day"

"smile and find
something wonderful
in every single day :)"

"watch D.Gray-man"

Silje plays:
Lavi
from D.Gray-man

Costume:
self-made
"took 1 week, cost £40.
The biggest challenge was
the huge hammer!"

The best thing about this
costume is:
"the pants and boots -
they're sexy XP"

I love this character because:
"HE'S DA AWSHUMEST EVAH!!!"

"everyone should cosplay!"

Helen plays:
Maka Albarn
from Soul Eater

Costume:
self-made
"I couldn't find the right
fabric for the skirt, so I had
to draw on all the black lines
with a fabric pen"

I love this character because:
"she's just awesome. Who
doesn't love a schoolgirl with
a huge scary weapon?"

"relax, take your time and enjoy the results"

Siobhan plays:
Coyote Starrk
from Bleach

Costume:
self-made
"took 2 months. The hardest
bit was sewing the fur"

I love this character because:
"he has a pimp coat and is just plain lazy"

"in the name of science"

Simon plays:
Mayuri Kurotsuchi
from Bleach

Costume:
self-made, plus friends
"took 1 month"

I love this character because:
"he's a psycho!"

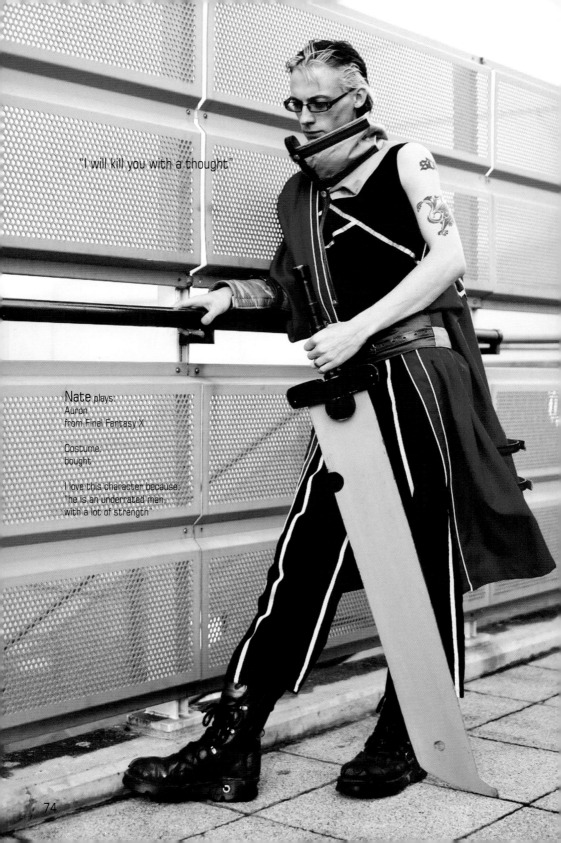

"I will kill you with a thought"

Nate plays:
Auron
from Final Fantasy X

Costume:
bought

I love this character because:
"he is an underrated man,
with a lot of strength"

74

"it doesn't matter if people cosplay the same characters at cons - the point is to have fun!"

Joanna plays:
Squall Leonhart
from Dissidia: Final Fantasy

Costume:
part bought, part commissioned
"cheers to Al and Emily for the
gunblade commission"

The best thing about this costume is:
"it keeps me warm, and the gunblade
is made of epic win!"

I love this character because:
"Final Fantasy VIII was the first
Final Fantasy game
I ever played"

"fly like a mouse, run like a cushion
be the small bookcase"

Rory plays:
Soundwave
from Transformers: Generation 1

Costume:
by James
"took 6 weeks, cost £30.
The biggest challenge is
dealing with the heat"

"don't play with fire"

Luke plays:
Space Marine Terminator -
Space Wolf
from Warhammer 40K

Costume:
self-made
"took 1 month, cost £110"

I love this character because:
"it's a space Viking"

77

"live your dreams"

Sere plays:
Eternal Sailor Moon
from SeraMyu

Costume:
self-made
"took 6 weeks, cost £90+.
Making the waistband was
quite challenging"

The best thing about this
costume is:
"it's so colourful"

I love this character because:
"she is kind to her friends, and
is bright, funny and clumsy -
just like me :)"

"the difference between a good and a great costume is effort, not experience"

Emily plays:
Sailor Mars
from SeraMyu

Costume:
self-made
"took a few months, on and off, cost £200. I used around 20 metres of sequins"

The best thing about this costume is:
"it's bright and spangly!"

I love this character because:
"she's strong, and a feminist"

"stay in school!"

Andrew plays:
Taokaka
from BlazBlue: Calamity Trigger

Costume:
self-made
"took 2 weeks, including one restart when
I switched materials. I used cotton drill and
copious amounts of felt"

The best thing about this costume is:
"giant paws!"

"don't go on a sunbed for too long - it's painful"

Anthony plays:
Joe Higashi
from King of Fighters

Costume:
self-made, plus Cat
"didn't take long and was quite cheap.
The most difficult thing was trying to
be thin enough to wear it"

The best thing about this costume is:
"the wig"

I love this character because:
"he's funny"

"eat well at cons
and have fun"

Emma plays:
Raphael Sorel
from Soulcalibur II

Costume:
self-made
"took 3 weeks. The breeches were
the most challenging, as they are
historically accurate so were very
fiddly to make"

The best thing about this
costume is:
"the jacket. It took less time
to make than I expected and
cost nothing"

I love this character because:
"he fences, as do I"

Kaman plays:
Taki
from Soulcalibur IV

Costume:
self-made

The best thing about this costume is:
"the boobs!"

I love this character because:
"I look like Jordan - but better"

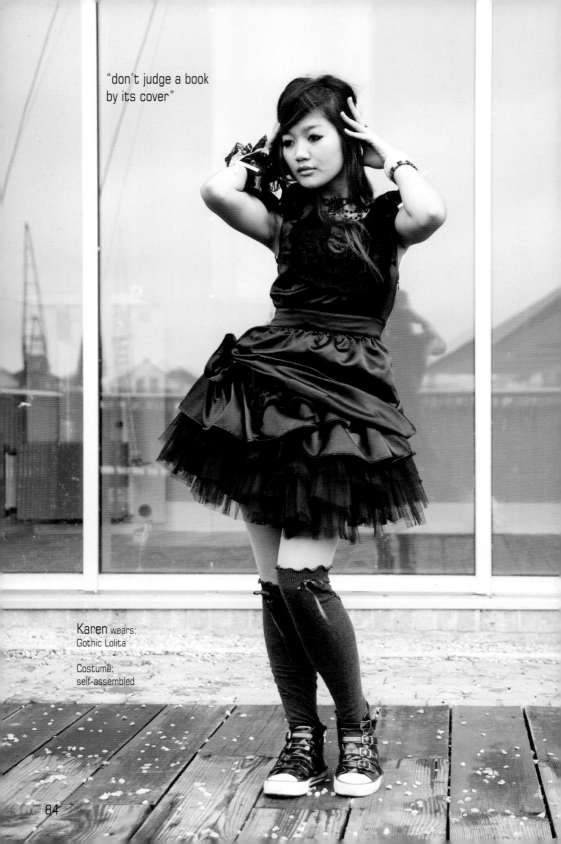

"don't judge a book
by its cover"

Karen wears:
Gothic Lolita

Costume:
self-assembled

"true happiness lies in cosplay!"

Emma wears:
Wa Lolita

Costume:
self-made
"there was a lot of woodwork involved in making the shoes. I also used an impressive 10 metres of lace"

The best thing about this costume is:
"the Maiko clogs"

"why so serious?"

Chris plays:
The Joker
from The Dark Knight

Costume:
self-made, plus a couple of tailors
"took six months, cost £600.
The hardest part is putting the
make-up on myself"

The best thing about this
costume is:
"it scares people, plus
I can sit down in it"

I love this character because:
"he's a funny psychotic"

"one man can make
a difference"

Lee plays:
Green Arrow
from Smallville

Costume:
bought and modified
"needed major modding
to make it fit right.
The hardest part was
finding the bow, which
took about a year
of searching"

The best thing about this
costume is:
"I finished it in time, and
the bow is the same as
the one in the show"

"where's my
bloody rum?!"

Sean plays:
Captain Jack Sparrow
from Pirates of the Caribbean

Costume:
self-made
"took over a year, cost £1000+"

The best thing about this costume is:
"my hat, love my hat!"

I love this character because:
"he is very interactive with the public,
plus he's cheeky and fun to play"

Jo plays:
Xena
from Xena: Warrior Princess

Costume:
self-made

"you are never going to win with thin little bird lips"

"learn to chug maple syrup"

Matt plays:
Robert "Rabbit" Roto
from Super Troopers

Costume:
bought and modified
"cost £300. Sourcing the items
was difficult and there was a lack
of good reference material"

The best thing about this
costume is:
"how it comes together
as a complete look"

I love this character because:
"he's a prankster who loves
fooling around"

Rob plays:
MacIntyre "Mac"
Womack
from Super Troopers

Costume:
bought and modified
"took 8 weeks,
cost £350. It was
hard to find specific
items from the USA,
like the exact shirt,
badges etc"

"I say we get out there and tw*t it!"

Raules plays:
Lister
from Red Dwarf

Costume:
self-made
"took 7 weeks. The hardest part was finding a leather jacket that could be destroyed and converted"

The best thing about this costume is:
"it's easy to wear"

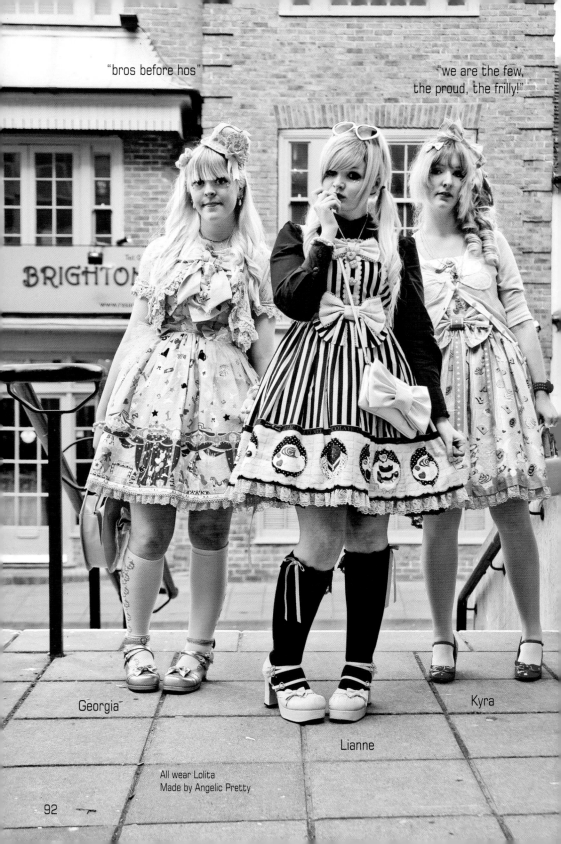

"bros before hos"

"we are the few, the proud, the frilly!"

Georgia

Lianne

Kyra

All wear Lolita
Made by Angelic Pretty

Hannah plays:
Chi
from Chobits

Costume:
self-made, plus Paulina
"the cape was bought, the rest took
around 8 hours solid. It wasn't too
costly, the most expensive part being
the wig, which was £30. The fitting
of the sleeves was the hardest bit"

I love this character because:
"she is from one of the first
anime I ever watched"

"don't destroy
the rainforest!!"

Emilie plays:
Deedlit
from Record of
Lodoss War

Costume:
by Lillyxandra

El plays:
Elf Bride
from Lineage 2

Costume:
by Amber
"Amber painstakingly followed the
reference to the last detail. To get the
perfect fabric for the chiffon part of the
skirt, she took an Alexander McQueen
dress apart"

The best thing about this
costume is:
"I get to be a girl!
I usually cosplay boys"

I love this character because:
"it's the only time you get
to wear a wedding dress,
without getting married!"

"long live the tsar!!"

Paul plays:
Alexei Automatov
(original creation)

Costume:
self-made
"took 2 months, scouring
car boot sales and costume
sales, cost £120"

I love this character because:
"it's unique and my
own creation"

"I think it's about time for
a nice cup of Earl Grey"

Alex plays:
Major Wilfred Quartermane
(original creation)

Costume:
self-made
"took 6 weeks. Getting everything ready in time
was a challenge, and it was hard to find a good
quality dark blue fur"

The best thing about this costume is:
"it gave me an excuse to mix a lot of different
costume making skills together"

I love this character because:
"he's a fun mix of furry and steampunk,
two fandoms which I enjoy"

"don't be afraid to be original"

Anaïs plays:
Doll
(original creation)

Costume:
self-made
"took 2 weeks, cost £100"

The best thing about this costume is:
"the mechanical winding key"

98

Silje plays:
Alexis the Androgynous
(original creation)

Costume:
self-made
"took one week, cost £30. Making the
hat was an insane task"

I love this character because:
"it's unconventional"

"coming soon near you - not!"

Lisa plays:
a Nurse
from Silent Hill

Costume:
self-made
"took 16 hours, cost £49. The mask
was the most challenging part:
ModRoc masks = hard!"

The best thing about this costume is:
"scaring people, and the blood"

I love this character because:
"it's fun to strut around like a zombie"

Eilidh plays:
Lisa Garland
from Silent Hill

Costume:
self-made
"took 3-4 hours. I mostly made
it at 1am in my back garden. The
only thing I had to buy was the
wig, for £16 - recycling is fun"

The best thing about this
costume is:
"the gore FX and coffee smell,
plus scaring people"

I love this character because:
"she's lovely and it's fun to
stumble about"

"I will think of something
inspirational to say later,
but now I must dance!"

"this is not narcissism,
it is just truism"

"everybody love
everybody"

Kerry plays:
Zhen Ji
from Dynasty Warriors 6

Costume:
self-made
"took 3 weeks, cost £100.
Styling the wig and making
the headdress was
a challenge"

Jacob plays:
Cao Pi
from Dynasty Warriors

Costume:
self-made, plus nan and dad
"took 1 month. The biggest
challenge was the sword, due to
its size and unusual shape"

"ninjas over pirates"

Darrin plays:
Ryu
from Ninja Gaiden Sigma

Costume:
self-made
"took 2½ weeks. It was
hard getting the bodysuit
to fit tightly"

"impossible? HA!"

Tab plays:
Siegfried
from Soulcalibur IV

Costume:
self-made
"took 2 months. I researched
heavily into thermoplastics and
other things like chain mail"

The best thing about this
costume is:
"the invisible armour!"

I love this character because:
"it's an impossible costume"

Matt plays:
Nightmare
from Soulcalibur

Costume:
by Tab

"the person who makes no mistakes is unlikely to make anything"

Holly plays:
Midna
from The Legend of Zelda:
Twilight Princess

Costume:
self-made
"took 1 week, cost £40. Painting on lycra was hard, painting on my back was impossible"

"spread love and cosplay"

Nicola plays:
Dark Zelda
from The Legend of Zelda

Costume:
self-made
"took 1 month, cost £100.
Most challenging was the
bodice, and styling the wig"

"alone we are geeks, united we cosplay"

Charlotte plays:
Avatar Kyoshi
from Avatar:
The Last Air Bender

Costume:
self-made
"took 2 months. It was
completely sewn by hand"

The best thing about this
costume is:
"the make-up - it's the only
time I look my age"

"always shoot for the moon - even if you fail, you'll land on the stars"

Adelaide plays:
a Warlock
from Granado Espada

Costume:
self-made
"took 3 days. The challenge
was making something for
the London Expo, which people
would eventually recognise"

I love this character because:
"Warlocks are the best -
very elegant and sexy,
without being rude"

"always keep glue
in your purse"

Larissa plays:
Felicia
from Darkstalkers

Costume:
self-made
"I spent ages looking for the right
fur, and I'd never used fur before.
The claws were made from an
Indian necklace"

I love this character because:
"she's a showbiz cat girl, who is
gentle and kind to everyone"

Laura plays:
Morrigan
from Darkstalkers

Costume:
self-made
"took 3 weeks. Getting through
doors is a challenge!"

I love this character because:
"she is really badass!"

"make costumes, not war"

Victoria plays:
Lucy
from Elfen Lied

Costume:
self-made
"took 1 week, cost £40. The challenge
was finishing it on time"

The best thing about this costume is:
"it was quick and easy to make"

I love this character because:
"she's cold and emotionless, and
protects herself any way she can"

"who the hell
do you think I am!"

Grace plays:
Yoko
from Gurren Lagann

Costume:
self-made
"took 1 month, cost £50"

The best thing about this costume is:
"it is detailed and accurate"

I love this character because:
"she is a very strong and independent
woman, who can take care of herself"

"laugh!"

Victoria plays:
Claves
from Eternal Sonata

Costume:
self-made
"took 2 months. The wig and shoes
made it more expensive, and the
shoes were fiddly because of the
details. It took a while to figure out
how to make the gauntlet!"

The best thing about this
costume is:
"how cute it is! There are also
loads of intricate bits"

I love this character because:
"she has such a beautiful costume,
even though she's a bit of a ditz"

Hannah plays:
Princess
from Battle of the Planets

Costume:
by father
"both the boots and the helmet
took a while to make"

I love this character because:
"her weapon of choice is a yo-yo!"

"thank God for
Teh Internets!"

Holly plays:
Ezio Auditore Da Firenze
from Assassin's Creed 2

Costume:
self-made, plus mum
"took 4 months, cost £50.
The challenge was getting
it accurate enough"

The best thing about this
costume is:
"the cape and hidden blade"

I love this character because:
"he is new, flamboyant and
from a great game series!"

Amy plays:
Jill Valentine
from Resident Evil remake

Costume:
self-made
"took 2 months to source the correct
kit and second-hand items. I've also
used airsoft gear and modified clothes"

The best thing about this costume is:
"I'm really proud of how the shoulder
pads and harness turned out"

I love this character because:
"I've always been a fan of the series,
and friends have often told me
I would suit the character"

Christine plays:
a Moogle
from Final Fantasy

Costume:
by The Luniactrics Project
Production Unit
"took 3 weeks"

I love this character because:
"it's a Moogle!"

"let's croak us
some toads!"

Tony plays:
Bucky O'Hare
from Bucky O'Hare

Costume:
self-made
"took 3 weeks, cost £100.
The hardest part was the
fur head, as it was my
first attempt"

The best thing about this
costume is:
"it reminds me of my childhood
and how good the shows were
back then"

"just be yourself and don't try to be someone else - unless you're in cosplay!"

Mark plays:
White Ranger
from Mighty Morphin
Power Rangers

Costume:
by Aniki
"cost £500"

I love this character because:
"it's been one of my favourites since I was young. The character has always been my hero"

"shift into turbo!"

Oliver plays:
Green Turbo Ranger
from Power Rangers: Turbo

Costume:
by Toei
"cost £2000. Made by
the official company who
produced Power Rangers"

Tania plays:
Yellow Turbo Ranger
from Power
Rangers: Turbo

Costume:
by Toei

"I don't cosplay to impress
or express, only to make
others happy"

Kimi-Chan plays:
Cursed Howl
from Howl's Moving Castle

Costume:
self-made
"took 3 months, cost £120.
The biggest challenge was sitting
down for hours on end, cutting
out all those feathers"

The best thing about this
costume is:
"each individual feather was
hand-sewn / glued and the
wingspan is 14 feet"

I love this character because:
"he is very similar to me in
personality"

"have fun and never give up"

"enjoy life - this is not a dress rehearsal"

James plays:
Laputian Robot
from Laputa: Castle in the Sky

Costume:
self-made
"took 100 hours, cost £225.
Large curved surfaces are very
difficult to make"

Leena plays:
Sheeta
from Laputa:
Castle in the Sky

Costume:
by Chibi

123

"off with their heads"

"eat, drink
and be merry,
for tomorrow
we will be
totally broke"

Moira plays:
The Red Queen
from Alice
in Wonderland

Costume:
self-made
"took 2 months, cost £400.
All the braiding and each
individual heart and bead
was hand-sewn on"

I love this character because:
"she's a crazy bitch! And I get
to scream and yell all day"

Jack plays:
Mad Hatter
from Alice
in Wonderland

Costume:
self-made
"took 2 months,
cost £300"

"meow!"

"you're not dreaming anymore"

Holly plays:
Alice
from Alice
in Wonderland

Costume:
self-made, plus Mum
and her friend
"took 6 hours, cost £70
due to the
Victorian boots"

Joshua plays:
Cheshire Cat
from Alice
in Wonderland

Costume:
self-made
"took 4 months.
The hardest part was
making the head"

Laban plays:
Batman
from Batman

Costume:
various sources
"the Reevz Hush cowl cost £150.
The belt was homemade. The boots
were a gift. The gloves were modified
by me, and the bodysuit and cape
are by HeroesAllianceUK.com"

I love this character because:
"he's brooding and dark - the
complete opposite of me"

"I'm a woman and I'm wonderful - get over it"

Emma plays:
Wonder Woman
from Wonder Woman

Costume:
self-made
"took 1 month, cost £50.
I had a lot of problems
with it, and it needs to be
remade, but I'm pleased
nevertheless"

"anything's possible!"

Kayleigh plays:
Shiva
from Final Fantasy X

Costume:
self-made, plus boyfriend
"took 2 weeks. The wig was a
challenge, but a few online
tutorials helped"

The best thing about this
costume is:
"my wig! It took so long!"

I love this character because:
"she's well cool!"

Nina plays:
Midna
from The Legend of
Zelda: Twilight Princess

Costume:
self-made
"took 52 hours, cost £100.
The challenge was the
pattern on the cloak"

I love this character because:
"her personality is interesting,
as she's both good and bad"

"hang in there when making
costumes - it'll be worth it!"

"I love my wife, Miruru"

Vincent plays:
Gundam Strike Noir
from Mobile Suit Gundam SEED
C.E. 73: Stargazer

Costume:
self-made
"took 11 months, working
evenings and weekends,
cost £250. The head and wings
were the most challenging.
Painting the whole thing was
troublesome too"

The best thing about
this costume is:
"it fits me!! It's my
first costume and
I am proud of it!"

"set yourself challenges and then smash them!"

Phoebe plays:
Wing Zero Gundam
from Gundam Wing:
Endless Waltz

Costume:
self-made
"took 1 year, cost £200.
Plenty of blood and
sweat, but no tears -
just happiness
at the end!"

Charlotte plays:
a Na'vi
from Avatar

Costume:
by Alexandra
"spent 3 hours painting
the body, 2 hours on the skirt,
and 4 hours braiding the hair"

I love this character because: "I really liked the film, especially
the graphics and the setting
of Pandora"

Alexandra plays:
a Na'vi
from Avatar

Costume:
self-made
"painting the body took 3 hours,
the costume and accessories
took 4 hours, and I spent
3 hours on the hair"

I love this character because:
"I loved the film, and it was
something new and exciting,
as well as challenging,
to try to replicate"

Rob plays:
Boba Fett
from Star Wars

Costume:
self-made
"took a year for the
second version"

The best thing about this
costume is:
"it is screen accurate"

I love this character because:
"it's Boba Fett, dude!"

"keep pod racing!!"

Jacob plays:
Anakin Skywalker
from Star Wars

Costume:
by Rubies
"cost £200"

The best thing about
this costume is:
"the ladies love it!"

I love this character because:
"he is small, like me"

"TPG FTW"

Aaron plays:
White Rabbit
from Alice in Wonderland

Costume:
Jacket and watch self-made,
fursuit by Rach
"wearing it is tough,
because of the heat"

The best thing about this
costume is:
"the fluffyness"

I love this character because:
"it's a funny character"

136

"curiouser and -- wait I've
heard this before"

Natasha plays:
Alice
from Alice in Wonderland

Costume:
part bought, part self-made
"took 2 days to make the
petticoat and accessories, style
the wig and alter the dress"

The best thing about this
costume is:
"acting sweet and innocent
in frills and bows"

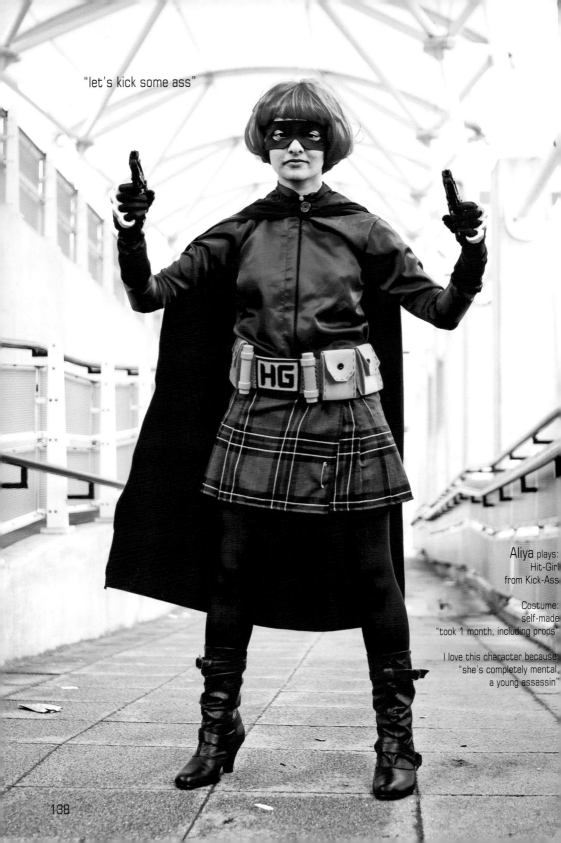

"let's kick some ass"

Aliya plays:
Hit-Girl
from Kick-Ass

Costume:
self-made
"took 1 month, including props"

I love this character because:
"she's completely mental,
a young assassin"

138

"have fun - that's
what life is"

Steven plays:
Kick-Ass
from Kick-Ass

Costume:
from Masquerade Costumes, Brighton
"took 3 weeks, cost £120. It was hard
getting the perfect fit and the right
look, as a wetsuit is wrong"

I love this charäcter because:
"he is cool, despite being a geek"

"live life on the
wild side!"

Laura plays:
Fran
from Final Fantasy XII

Costume:
self-made
"took several months, cost £180.
The details on the armour took
the longest to make. The shoes
were also challenging, but worked
well in the end"

I love this character because:
"she's unusual, mysterious and
her outfit is outrageous"

"FOR THE ALLIANCE!"

Charlotte plays:
Aetheria
from World of Warcraft

Costume:
self-made
"took 12 hours, cost £200. The challenge
was keeping the headdress up!"

The best thing about this costume is:
"my furry arms!"

I love this character because:
"it's elegant, furry and beady"

141

Michael plays:
Zombie Tarzan
from Tarzan

Costume:
self-made
"it took a while to come up with
a loincloth that wouldn't fall off.
The rest was fairly easy to make"

The best thing about this
costume is:
"it's creepy as hell"

I love this character because:
"Tarzan is an amazing character
on his own, but if you add the
rotten flesh and blood,
it becomes flawless"

"leg itchy... me scratched... flesh
came off... Terk brain very tasty...
still hungry... want mooore..."

"don't be afraid to cosplay whatever you want - and stay original!"

Anaïs plays:
Belle Undead
from Beauty and the Beast

Costume:
self-made
"took 3 months, cost £50.
Challenges include making
a hoop skirt - and actually
wearing the costume"

The best thing about
this costume is:
"the ability to
scare people"

143

"the music meister sings the song
that the world wants to hear"

Holly plays:
Starfire
from Teen Titans

Costume:
self-made
"took 2 months :)"

The best thing about this costume is:
"it shows off everything!"

I love this character because:
"she can beat up Wonder Woman"

"comic books own anime!!"

Kate plays:
Black Cat
from Spider-Man

Costume:
bought and modified
"took 2 weeks. The hardest thing
is walking in the boots!"

"nothing can stop the will to power!"

Christopher plays:
Lezard
from Valkyrie Profile 2: Silmeria

Costume:
self-made, plus friend's gran
"took several months to get
the fabric done and all the
accessories sorted. I used a
horse bit for the cape clasp, and
the boots are riding boots. The
book cover is papier-mâché"

I love this character because:
"he is geeky and flamboyant,
but will devastate anyone with
his magic and ambition!"

"aim for 100% perfection,
and you'll get close to it"

Melissa plays:
Hrist
from Valkyrie Profile 2: Silmeria

Costume:
self-made
"took 7 months. The costume was
made from Wonderflex. The helmet
and halberd head were made from
corrugated card, foam and
papier-mâché"

I love this character because:
"she is one of the Valkyries"

147

"I'm crossing the Rubicon...!"

Yuki plays:
Austria
from Hetalia

Costume:
self-made
"I used the real pattern
from the 18th century and
spent quite a long time
making the weapon"

The best thing about this
costume is:
"the historical accuracy and
nice materials!"

I love this character because:
"I love all of his costumes -
they're so beautiful"

"boy's love for everyone!"

Lilith plays:
Hungary
from Hetalia

Costume:
self-made
"took 1½ weeks, cost £70.
I rushed the button sewing!
The most challenging thing was
sewing cashmere wool"

The best thing about this
costume is:
"historical uniforms rule!"

I love this character because:
"she saved Austria's ass!"

"be original, not just another Naruto! :P"

DEATH NOTE

Iain plays:
Death Note
from Death Note

Costume:
self-made
"took 20 hours. I used bamboo
and coat hanger wire for the frame,
plus cardboard and fabric, all bound
together with glue and duct tape"

The best thing about this costume is:
"people can sign it!"

Dan plays:
Ryuk
from Death Note

Costume:
self-made
"my girlfriend and I made
it in 3 hours. It's all about
the delivery"

The best thing about this
costume is:
"my eyes"

I love this character because:
"he is a god"

"do what you love,
love what you do"

Karen plays:
Moon
(original creation)

Costume:
furry bits self-made, rest bought
"the sculpting took 1 week, waiting for
everything to cure took almost as long"

The best thing about this costume is:
"the real deer antlers"

I love this character because:
"its elegance is very different
from how I am in real life"

"ALL YOUR SHINIES ARE BELONG TO US"

Ruth plays:
Slith
(original creation)

Costume:
self-made
"took 1 year to make,
cost £200+"

The best thing about this
costume is:
"THE TAIL!"

I love this character because:
"it's my LARP character"

153

"feed me more
Pocky, please"

Kat plays:
Yuzuriha Nekoi
from X/1999

Costume:
self-made
"took 3 days solid.
Most of that time was
spent painting. Getting
the sleeves and obi
right was the
hardest part"

The best thing
about this
costume is:
"people can hear
me approaching,
due to the bells"

Amy plays:
Arashi Kishu
from X/1999

Costume:
self-made
"took 2 weeks, cost £50.
There were many many pleats,
which means too much ironing"

Lauren plays:
Kirin
from Pet Shop of Horrors

Costume:
self-made
"took 4 days, cost £70.
Painted using a paint roller"

The best thing about this costume is:
"I really enjoyed making it! It's my first
cosplay and I was a bit ambitious"

I love this character because:
"the Kirin is rare and I didn't want
any duplicates. She doesn't do much
though, just looks pretty"

"give it a go, you might just be surprised"

Nikki plays:
Shurei
from The Story of Saiunkoku

Costume:
self-made
"the main challenge was working out
how to make the headdress,
and cutting the pink fabric (slippy!)"

"life is short - use it well"

Annette plays:
Selina Won Kitten
from an original design by Derek

Costume:
self-made
"took 2 months, cost £70+.
There were plenty of small details
to work on"

The best thing about this costume is:
"there's a damn cannon - in my hat!"

I love this character because:
"it was designed especially for me"

Louise plays:
Setsuka
from Soulcalibur IV

Costume:
self-made
"the kimono took 9 months
of hand-painting! But it was
definitely worth it!"

The best thing about this
costume is:
"the kimono and para-sword"

I love this character because:
"she's kick-ass!"

"take it easy and
have fun cosplaying"

James plays:
Cervantes
from Soulcalibur III

Costume:
self-made
"took 1 month, cost £150.
The gold trim and pattern
painting were the
most challenging"

I love this character because:
"it's a detailed costume, good
back story and fun to play"

"beware the possums"

Jade plays:
Poison Ivy
from Batman

Costume:
self-made, plus eBay
"took 5 months, on and off.
The main challenge was trying
to find the best way to attach
all the tiny ivy leaves"

I love this character because:
"simple, she's kick-ass!"

"I love Bea Arthur!
...Chimichangas!"

Priya plays:
Punk Deadpool
from Deadpool

Costume:
self-made
"took 4 months, cost £80.
It was my first time working
with this material"

The best thing about this
costume is:
"the fact that I can't
see a thing"

Kerry plays:
Lara Croft
from Tomb Raider

Costume:
self-made
"took 2 weeks, cost £150"

The best thing about this costume is:
"the guns and the boobs"

I love this character because:
"she is my childhood hero"

"do what you love - don't let people's opinions get you down!"

Leonie plays:
Jill Valentine
from Resident Evil

Costume:
self-made
"cost £160. The shoulder pads
took 8 hours and were hell!"

The best thing about this
costume is:
"the S.T.A.R.S. watch -
a nice little touch I love"

I love this character because:
"she's a strong independent
woman who saves the world
from zombies!"

163

"you can be yourself when you cosplay - nothing else matters"

Donna plays:
Scorpion
from Mortal Kombat

Costume:
self-made
"took 2 months, cost £90.
The challenge was to make
a striking costume on
a small budget"

I love this character because:
"he kicks ass! Best Mortal
Kombat character ever!"

Chloë plays:
Kamikirimusi
from Soulcalibur IV

Costume:
self-made, plus mum and gran
"took 1 month, cost £60+"

The best thing about this
costume is:
"the fun of wearing and
making it"

I love this character because:
"she has a great fighting style
in the game"

185

"real ninjas don't need
headbands - they have
ULTIMATE DEFENSES
instead"

Kathleen plays:
Gaara
from Naruto

Costume:
self-made, plus sister
"took 3 months to make the cloak and
chest protector, 1 month to make
the gourd"

I love this character because:
"his back story is the best out of
every character I know"

"I will take over you
one day - believe it!"

Charley plays:
Naruto Uzumaki
from Naruto

Costume:
by Lucy
"took 3 weeks, cost £30.
Making the shoes was
a challenge"

I love this character because:
"his character and personality
are like mine, and he's got
orange gravity-defying hair!"

"this is for fun -
don't take it
too seriously :)"

Rebecca plays:
Celine Jules
from Star Ocean 2

Costume:
self-made
"took 6 months. The hat was the
hardest part - it took 4 attempts
and making something that defies
physics is hard!"

The best thing about this
costume is:
"the hat. It defies gravity!"

I love this character because:
"she's sassy, crafty, magic and
always gets her way!"

Karl plays:
Dark Magician
from Yu-Gi-Oh!

Costume:
self-made
"took 1 month, cost £30"

Steph plays:
Eowyn
from Lord of the Rings

Costume:
self-made, plus Paul
"cost under £100. It's made of authentic
materials - leather, steel and fabrics. The
costume is as authentic as it can be"

I love this character because:
"her courage and determination to be more
than is expected of her is awe-inspiring"

"enjoy every day to the full -
just let convention days be
that little bit more special"

Silantre plays:
a Night Elf Druid
from World of Warcraft

Costume:
self-made
"I've been working on this cosplay
for around 2 years. I've had to learn
several new techniques. The hood
was made by covering a plastic
bag in over 120 small ovals"

"cosplay forever - you can achieve anything if you try!"

Tracy plays:
Padme Amidala
from Star Wars

Costume:
self-made, plus Christine
"took 2 months, cost £60. The challenging part was the embroidery, and hand-sewing the small roses onto the cape"

The best thing about this costume is:
"the details and embroidery"

I love this character because:
"she wears beautiful costumes"

"do what you want for YOU
and no one else"

Jenny plays:
Femtrooper
from Star Wars

Costume:
bought and modified by Kelly Jane
"cost £250+. Scaling it down to
size was hard!"

The best thing about this costume is:
"I get to wear it in support of my
charity group"

"hug a charmander TODAY!"

Emma plays:
Mirka Fortuna
from Trinity Blood

Costume:
self-made
"took 3 weeks. All the appliqué was
done by hand. I also built the armour"

The best thing about this costume is:
"it's so different to what I normally
wear. I normally crossplay"

I love this character because:
"she's a vampire in PINK!!"

174

"even if you don't think you look good, someone will think otherwise!"

Natasha plays:
Queen Esther
from Trinity Blood

Costume:
self-made
"this was all made last night and it's not finished, but it's so pretty that I had to wear it anyway"

I love this character because:
"she is a girl who was destined for greatness from birth, even though she is troubled"

"start early or die trying and don't despair"

Mags plays:
Ulquiorra
from Bleach

Costume:
self-made
"took 3 months. It was a challenge to get the wings to open and close"

The best thing about this costume is:
"the tail - it's pullable and fluffy"

I love this character because:
"he's emo and lovely"

"never think 'I can't',
think 'how can I?'"

Neil plays:
Alphonse Elric
from Fullmetal Alchemist

Costume:
self-made
"took 5 months, cost a lot
of blood, sweat and tears.
It's made of foam and latex"

The best thing about this
costume is:
"the reaction I get
from wearing it"

"$e=mc^2$"

Bianca plays:
Lulu
from Final Fantasy X

Costume:
self-made, plus friends
"it took too long!!! I had to call in
friends to help!"

The best thing about this costume is:
"it's badass and I feel cool"

I love this character because:
"she's tough and dark"

Joanna plays:
Yuna
from Final Fantasy X

Costume:
from eBay
"it was hard to get the
mismatching contact lenses,
and putting the whole cosplay
on was quite tricky, requiring
a lot of double-sided tape!"

I love this character because:
"she starts off quite innocent
and sheltered, but grows
into a strong character"

James plays:
Night Crawler
from X-Men

Costume:
self-made, face make-up by Nick
"took 3 weeks, plus 5 hours for my
face, cost £50. The design for the
scars was the biggest challenge"

The best thing about this costume is:
"the long curvy tail"

I love this character because:
"BAMPH!"

"have fun, be yourself, but try
not to attack anyone with a
stick if they don't agree"

Stacey plays:
Siryn
from X-Factor Investigations

Costume:
self-made
"I bought the base bodysuit on eBay, then
made the yellow interface and wings myself.
This took way too much hand-stitching for
my fingers to handle!"

The best thing about this costume is:
"I get to walk around in lycra all day,
without getting hit on ha ha"

I love this character because:
"she's one of the few good Marvel
heroes from our part of the world"

"mmmm brains"

Nicholas plays:
Zombie Jack Sparrow
from Pirates of the Caribbean

Costume:
self-made, plus friends
"took 1 month. It was hard to
get the hair right and to find
all the right fabrics"

I love this character because:
"I've got a jar of dirt...
and guess what's inside it?"

"don't be afraid to make
a fool of yourself -
nobody cares!"

Silje plays:
Zombie Cinderella
from Cinderella

Costume:
self-made
"took 2 weeks, cost £30.
The bodice was a challenge -
very fiddly!"

The best thing about this
costume is:
"it's my first sewing project
and I'm dead proud"

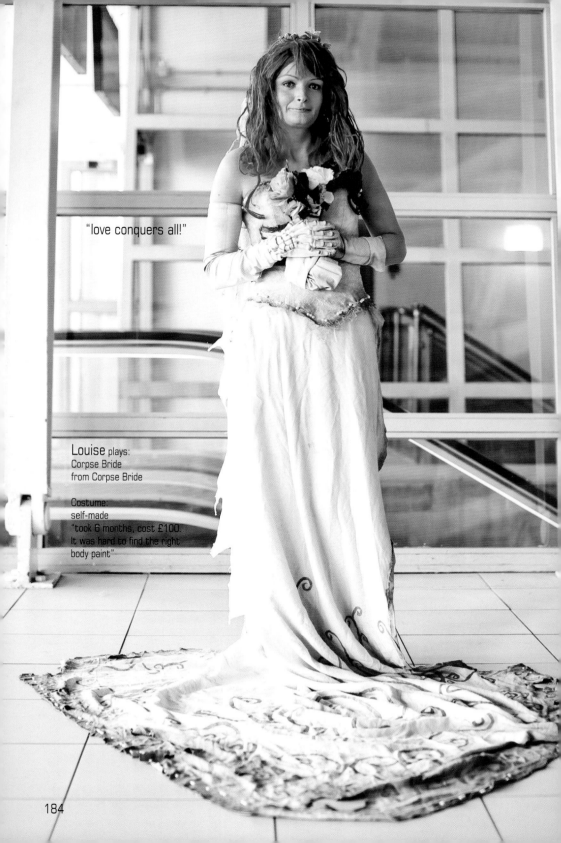

"love conquers all!"

Louise plays:
Corpse Bride
from Corpse Bride

Costume:
self-made
"took 6 months, cost £100.
It was hard to find the right
body paint"

Paul plays:
Jareth
from Labyrinth

Costume:
self-made
"took a few months, cost £70.
It's challenging to walk in heels"

I love this character because:
"it's David Bowie!"

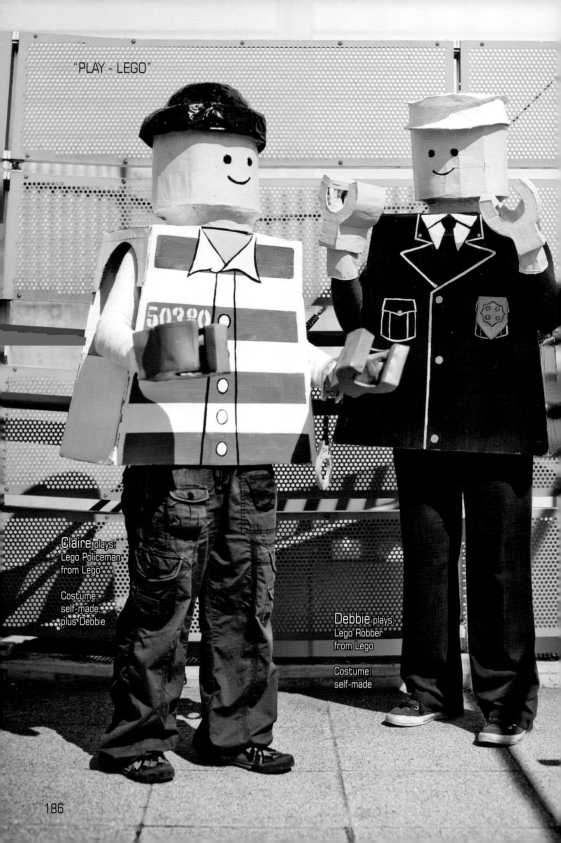

"PLAY - LEGO"

Claire plays:
Lego Policeman
from Lego

Costume:
self-made,
plus Debbie

Debbie plays:
Lego Robber
from Lego

Costume:
self-made

186

"HUG ME"

Leena plays:
Paddington Bear
from Paddington Bear

Costume:
self-made
"the head and hat were
especially challenging"

The best thing about this
costume is:
"the coat and the hugs"

WELCOME

BB

"Sniper Island is
in our hearts"

Russell plays:
Sogeking
from One Piece

Costume:
self-made
"took 50 hours, cost £80"

I love this character because:
"he is really funny"

Ali plays:
Wax Luffy
from One Piece

Costume:
self-made
"took 1 month.
I made everything myself"

"I'm going to be
the Pirate King"

"if you don't love cosplaying,
you're doing it wrong"

Michael plays:
Freakazoid
from Freakazoid!

Costume:
part self-made, part bought
"didn't take long, was quite
cheap, and simple. But the
gloves were a pain"

The best thing about this
costume is:
"it's fun to wear"

I love this character because:
"he's mental"

"RAN RAN RUUUU!"

Ellie plays:
Ronald McDonald
from McDonald's

Costume:
by Arkayen
"cost just under £100. The make-up
took me over an hour!"

The best thing about this costume is:
"how colourful and shiny it is!"

I love this character because:
"he's so much fun to prance around as"

Kieran plays:
Commander Adama
from Battlestar Galactica

Costume:
bought
"I'm still annoyed that I couldn't
get a FiveseveN for it"

The best thing about this
costume is:
"I am a sucker for uniforms!"

I love this character because:
"Adama is just a god
amongst men"

"um... my name is Pot, Stuart Pot!"

Jill plays:
2-D
from Gorillaz

Costume:
self-made

Katrin plays:
Murdoc Niccals
from Gorillaz

Costume:
self-made

193

"be arty and original"

Zarah plays:
Arwen
from Lord of the Rings

Costume:
self-made
"took 2 months, cost £40.
It was very challenging,
especially the shape of the
sleeves and the high collar.
Getting it as close to the
original was tricky, but fun!"

I love this character because:
"the film is my favourite of
all time and I'm obsessed
with elves! They are magical,
wise, kind healers and
forever beautiful"

"DWARVES ALL
THE WAY"

Adrian plays:
Gimli
from Lord of the Rings

Costume:
by Zarah
"took 1 month. It is mostly made
from found materials, old belts,
left-over trimming and imitation
chainmail fabric"

I love this character because:
"he is the ruler of the Glittering
Caves and he deserves to be
seen everywhere"

"love and live in harmony with nature"

Adam plays:
Aspharr
from N3: Ninety-Nine Nights

Costume:
self-made
"took 2 weeks, cost £60.
Getting the armour to stay on
the costume was a challenge"

I love this character because:
"I'm drawn to knight chivalry and
gentlemanly characters who have
a strong sense of justice"

"embrace cosplay,
but keep it safe
(don't glue yourself
into your costume)"

Natasha plays:
Inphyy
from N3: Ninety-Nine Nights

Costume:
self-made
"took a few days. Mainly made from
craft foam and red satin. It's still
going through revisions"

I love this character because:
"she fights for justice and love!"

"bring it on!"

Ginyajuu plays:
Mononoke
(original creation)

Costume:
by Clockwork
Creature Studio
"cost a lot, but worth
every penny!"

"don't be afraid
to cosplay"

Bethan plays:
Dragon Knight
(original creation)

Costume:
self-made
"took 11 months. This was
the first costume I made myself -
no sewing!"

The best thing about this
costume is:
"I'm a dragon!"

I love this character because:
"I feel powerful"

"keep calm and carry on cosplaying!"

Pez plays:
Faize Sheifa Beleth
from Star Ocean: The Last Hope

Costume:
self-made
"took 3 months, cost £100.
It was hard to figure out the
order / layers of everything"

I love this character because:
"everybody loves space elves"

Tanzie plays:
Necromancer
(Vabbian armour)
from Guild Wars

Costume:
self-made
"took 10 months, on and off.
Materials mostly came from
charity shops and eBay"

"party on, dudes"

Sam plays:
Lord Braska
from Final Fantasy X

Costume:
self-made
"took 3 months, I lost track
of the cost"

I love this character because:
"he looks good and has an
interesting costume, plus
he is selfless and noble"

"don't worry about it, just try it!"

Nicola plays:
Tomoyo
from Tsubasa:
Reservoir Chronicle

Costume:
self-made, plus friend
"took 1 week for the fabric
side, plus an extra week for
everything else. Cost £70.
Challenges included getting
the headdress to work,
it's made from a
coat hanger!"

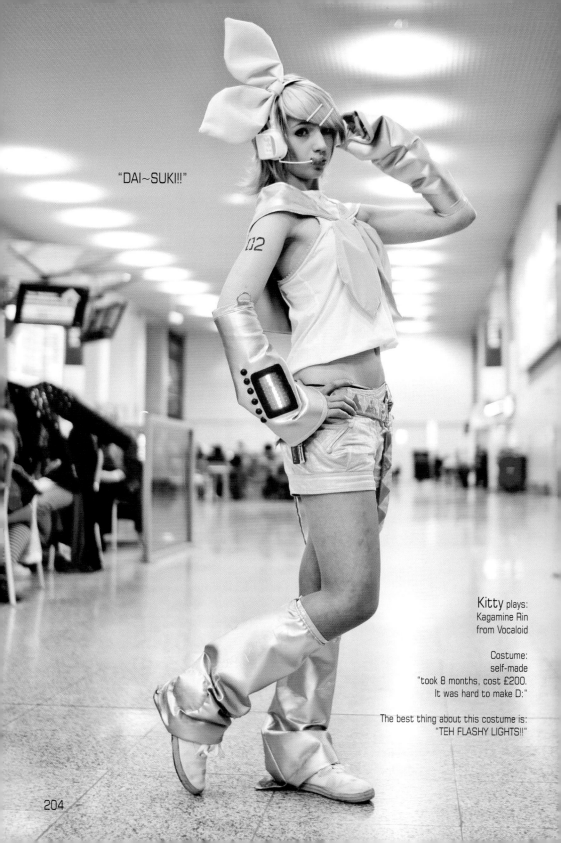

"DAI~SUKI!!"

Kitty plays:
Kagamine Rin
from Vocaloid

Costume:
self-made
"took 8 months, cost £200.
It was hard to make D:"

The best thing about this costume is:
"TEH FLASHY LIGHTS!!"

"be yourself and
be happy!"

Sally plays:
Hatsune Miku
from Vocaloid

Costume:
bought and modified
"cost £100. The outfit is
from Bodyline. My brother
and me made the LED
headset - it was tough!"

The best thing about this
costume is:
"the headphones light up"

I love this character because:
"she is cute and
very talented"

205

"Mwahaha"

Louise plays:
Queen Beryl
from Sailor Moon

Costume:
self-made
"took 4 months, on and off.
It wasn't very challenging,
but the nails make it hard
to do anything"

The best thing about this
costume is:
"the shoulder horns.
Air Dough is amazing!"

I love this character because:
"she's eeeevil!!"

"I like cereal :)"

Laura plays:
Sailor Mars
from Sailor Moon

Costume:
self-made

I love this character
because:
"she is a bitch!"

Simon plays:
Eternal Sailor Venus
from Sailor Moon

Costume:
by Laura
"took 1 week"

"stay super!!!"

Ben plays:
Captain Falcon
from F-Zero

Costume:
self-made
"took 6 hours"

I love this character because:
"he reeks of awesomeness!"

"I am very warm"

Chris plays:
Luigi
from the Mario games

Costume:
by Allison
"it was given to me as
a birthday present"

The best thing about this
costume is:
"it just looks ridiculous"

Joe plays:
Bowser
from the Mario games

Costume:
by a friend
"cost a lot. It's hot!"

The best thing about this
costume is:
"the eyes"

I love this character because:
"it's Bowser - the one and only"

"never give up on
finding what makes
you truly happy"

Chris plays:
Lucario
from Pokémon

Costume:
self-made, plus Hejinglan
"took 7 weeks, cost $700.
The biggest challenge was the
scarcity of supplies and fabrics"

The best thing about this
costume is:
"the amazing realism of the eyes"

I love this character because:
"he's noble, loyal and caring
to a fault"

"cosplay is for fun, not fashion"

Holly plays:
Space Paranoids Sora
from Kingdom Hearts

Costume:
self-made
"took 1 month,
cost £25. I used
10 metres of
reflective tape"

"Kingdom Hearts rocks
mah socks"

Laura plays:
Sora
from Kingdom Hearts II

Costume:
self-made
"the hair is made from two wigs
sewn together"

The best thing about this costume is:
"the shoes, because they took bloody
ages to figure out"

I love this character because:
"he's loyal, caring and courageous"

"some may call us weird - I call us unique!"

Kelly plays:
Axel
from Kingdom
Hearts

Costume:
wig and weapons self-made,
coat from eBay
"cost £150+. The chakram
weapons are styrofoam and
papier-mâché. The hardest part
was the wig - I made the
widow's peak myself, and it
took a while to get right!"

214

"Kingdom Hearts cosplay forever!"

Jenny plays:
Demyx
from Kingdom Hearts

Costume:
sitar self-made, coat from eBay
"the sitar took 20 hours in total,
the wig took half an hour to cut
and style"

"be yourself, no matter what they say"

Joe plays:
Demyx Water Clone
from Kingdom Hearts

Costume:
self-made, plus Emily and eBay
"the sitar took 2 weeks, cost £60.
The coat was made by Emily in
12 hours. Emily also styled the
wig, which took 1 week and was
finished at 3:25am this morning.
The Zentai suit was from eBay"

The best thing about this
costume is:
"it's anonymous, but
still awesome"

"doesn't matter if it's not 100% accurate - just have fun!"

Emily plays:
Axel Fire Clone
from Kingdom Hearts

Costume:
self-made, plus eBay
"the jacket was sewn from scratch in 24 hours. The wig was created from 3 other wigs. The weapons were made by a friend, and the Zentai suit was from eBay"

The best thing about this costume is:
"I'm completely red. What is there not to like?!"

"I'll be back"

Anthony plays:
The Terminator
from The Terminator

Costume:
self-made
"took 1 year, cost £400"

I love this character because:
"it scares the cr*p out of people"

"don't eat the yellow snow"

Jack

Bill

Stu

All play Metrocops
from Half-Life 2
All costumes by Jack

"keep it real"

Daniel plays:
Raikov
from Metal Gear
Solid 3

Costume:
self-made

Paul plays
Big Boss
from Metal
Gear Solid

Costume:
self-made

Victoria plays:
The Boss
from Metal Gear Solid 3

Costume:
self-assembled

"North East cosplayers FTW"

Craig

Angela

Both play GDI Soldiers
from Command & Conquer
Both costumes by Alex

Henry plays:
The Scarecrow
from Batman

Costume:
self-made
"the clothes were dyed brown and
cut / stitched up. The hat was spray
painted. The hardest part was finding
good materials for the mask"

I love this character because:
"he's an underappreciated
Batman villain, and it's
fun to be in character"

Madison plays:
Green Lantern
from DC Comics

Costume:
by Paul
"took 1 day. It's made from
spandex and leather"

"original costumes are great for expressing your personality - try one!"

Tab plays: Magnus Pie from an original comic

Costume: self-made
"this was made a few days before a party, but it turned out really well. The corset and hat were both made from scratch by me, so I feel proud wearing them"

The best thing about this costume is:
"all the steampunk bling!"

I love this character because:
"he's so damn cocky, but also sexy"

"my continuing participation as
Cogsworth is a tribute to my mum -
the world is sadder without her, so
I have to make it happier!"

Matthew plays:
Captain Cogsworth
from Captain Cogsworth
and Co.

Costume:
self-made, plus Tab
"took 2 weeks, cost £200.
The trousers and corset were
extremely thick, and hard to get
through a sewing machine"

The best thing about this costume is:
"the headwear - the helmet is very light
and well painted, and the hat
is beautiful"

I love this character because:
"it's me from another dimension! I also
get to invent the silly Russian accent"

225

Sonia plays:
Shura
from Soulcalibur IV

Costume:
self-made
"took 2 days, cost £60. The challenge
was making the demon skull and fixing
it to the shoulder"

The best thing about this costume is:
"chaps!"

I love this character because:
"she looks so much like me!"

"craft foam and hot glue are a cosplayer's best friends!"

Yasaman plays:
Yoshimitsu
from Soulcalibur II

Costume:
self-made
"cost £30. I managed to source most of my materials from home, e.g. coke bottles, camping mats, bamboo which was holding up tomato plants! There is a lot of armour so the best stuff to use was foam, as it's light"

The best thing about this costume is:
"the mask"

I love this character because:
"he is completely insane but an awesome fighter"

227

"how do we know if we exist?"

Catherine plays:
Vivi
from Final Fantasy IX

Costume:
self-made
"took 6 weeks, cost £30"

I love this character because:
"he's really cute!"

"black magic? This is how you use black magic *blast*"

Kayla plays:
Black Waltz No. 2
from Final Fantasy IX

Costume:
self-made, plus family and friend
"took 6 months. The wings were made
from B&Q wire, the witch's hat from
fleece and stuffing, the hoop skirt was
from a prom dress which was resized
and reshaped, and I bought loads of
halfprice fabric from Abakhan"

The best thing about this costume is:
"I could take off in strong winds"

"da - na - na - naaah!"

Giuseppa plays:
Link
from The Legend of Zelda

Costume:
self-made
"took 1 week, cost £135. Some things, like
the talking Navi, I made back in March. I was
really up against the clock on this one, which
was by far the biggest challenge"

The best thing about this costume is:
"there were a lot of 'first times' that
actually turned out to be rather
successful (e.g. belts, gloves,
boot covers, talking/sound props)"

I love this character because:
"he's iconic"

"keep smiling, be happy, and enjoy every day :)"

Becca plays:
Princess Zelda
from The Legend of
Zelda: Twilight Princess

Costume:
self-made
"took 2 weeks, cost £100.
The challenges were making the
armour and sewing, because
I'm really not very good!"

The best thing about this
costume is:
"the painting I got to do on it"

I love this character because:
"Zelda was the first thing that got
me into anime, games and cosplay"

"God bless America"

Helen plays:
100% A-merican
Zombie Tourist
from Resident Evil

Costume:
self-assembled
and modified

Steph plays:
Generic Zombie
from Resident Evil

Costume:
self-assembled
and modified

"kill or be killed"

Ekaterina plays:
Zombie Esmeralda
from The Hunchback
of Notre-Dame

Costume:
by Anaïs
"took half a day, cost £20.
The hardest part was
the corset"

The best thing about
this costume is:
"it never needs washing,
but the blood builds up
every time it's used"

I love this character because:
"I've always imagined myself as
a gypsy, and the zombification
is an exciting twist"

"keep being scared"

Luke plays:
Freddy Krueger
from A Nightmare
on Elm Street

Costume:
self-made, plus friend
"the make-up took 1½ hours,
total cost was under £20"

I love this character because:
"he's one of the first true
slasher movie villains"

"hello world, how are you today?"

Anaïs plays:
Bubble Head Nurse
from Silent Hill 2

Costume:
self-made
"it was made almost for
free, with things found in
my home. With the mask
on, I have limited vision,
so hearing, seeing
and walking is
almost impossible"

Silje plays:
Bubble Head Nurse
from Silent Hill 2

Costume:
self-made, plus Anaïs

"Pyramid Head needs sugar!"

David plays:
Pyramid Head
from Silent Hill

Costume:
by Caramelloube.deviantart.com

The best thing about this
costume is:
"scaring small children"

I love this character because:
"he is brutal"

"cosplay is supposed to be fun - enjoy!"

Rach plays:
a Licker
from Resident Evil

Costume:
self-made
"took 2 weeks, cost £40"

The best thing about this costume is:
"the brains scare everyone!"

"I love Lamp"

Sam plays:
Rikku
from Final Fantasy X-2

Costume:
self-made
"took 1 week. It was a last minute
cosplay, which nearly killed me from
lack of sleep!"

The best thing about this costume is:
"it's comfy"

I love this character because:
"she's cool"

"comfort before looks"

Lynsey plays:
Beatrix
from Final Fantasy IX

Costume:
self-made
"took 3 months, cost £150. Fitting everything correctly was a challenge"

The best thing about this costume is:
"it's fairly comfortable and cool"

I love this character because:
"she's a strong female, who wears a feminine outfit"

"why so serious?
Black rubber?
No thanks!"

Ben plays:
Adam West Batman
from Batman

Costume:
various sources
"took over six years of research and
work, cost almost £1000. I made the
utility belt, everything else was crafted
by friends or professionally made. The
boots and gloves were made using the
original patterns from the show"

I love this character because:
"it is a character I grew up with, and
learned many life lessons from"

"peace and love
and spandex"

Paul plays:
The Flash
from DC Comics

Costume:
self-made
"I've been making costumes
since I was 11 years old. They
generally take between 1 day
and 2 weeks, depending on
the design"

"regrets are a waste of good drinking time!"

Matt plays:
Lieutenant Charles Davenport
from Flight of the Valkyrie

Costume:
self-made
"took 2 months, cost £300.
The armour and backpack were
the biggest challenge"

The best thing about this costume is:
"the backpack, includes a transmitter
and phone"

I love this character because:
"it's an original concept that allowed
me to be as creative as possible"

"keep your eyes on the sky"

Sean plays:
Count Louis de Theudubert
from Flight of the Valkyrie

Costume:
self-made
"took a few months, making
props mostly"

The best thing about this costume is:
"it's my own creation"

I love this character because:
"he's bold, the leader, and a lot of fun"

"be creative with your costumes -
stand out from the rest!"

Venetia plays:
Volk The Huntress
(original creation)

Costume:
self-made

Jordan plays:
Vovin Levitas
(original creation)

Costume:
self-made,
plus friends

"if it makes you happy, that's good enough for me"

Daryl plays:
Pendulum Kage
from Flight of the Valkyrie

Costume:
self-made
"took 3 months, cost £300+.
The challenge was finding the
reference to match the character"

The best thing about this costume is:
"it's an original creation and lighter
than my other cosplays"

I love this character because:
"it reflects my love of steampunk
and martial arts"

"oh my, oh my,
how will the
story end?"

Karl plays:
Drosselmeyer
from Princess Tutu

Costume:
self-made
"took 7 weeks, cost £50.
Most of the costume is
sewn, but I also
used card"

"stay safe - you never know when the world is going to end"

Tony plays:
Kefka
from Dissidia: Final Fantasy

Costume:
self-made
"cost £150. The hardest part was the torso"

The best thing about this costume is:
"he is creepy :)"

I love this character because:
"he is evil and blows up the world"

247

"go out and have fun
in cosplay"

James plays:
Lord of Darkness
from Legend

Costume:
self-made
"took 2 weeks, cost £90. Making
the head cast and sculpting the
face was a challenge, but I'm
very pleased with the result"

The best thing about this
costume is:
"the mask - it came out really
well. I was pleasantly surprised
by how well it fitted"

I love this character because:
"he has an evil sort
of charisma"

"be creative!"

Yaya plays:
Carmilla
from Vampire
Hunter D

Costume:
self-made
"took 5 weeks, cost $500.
This is the most complicated
costume I've ever made.
I won the Yume Cosplay prize,
which was a trip to Japan and
a shopping spree in Tokyo"

"Beetlejuice,
Beetlejuice,
Beetlejuice!!"

Begoña plays:
Lydia Deetz
from Beetlejuice

Costume:
self-made
"I made this really quickly,
so it could be ready for the
Cosplay Cruise and another
event in Paris. I used
25 metres of 3 different
kinds of fabric, and it
was really cheap!"